RON MUECK

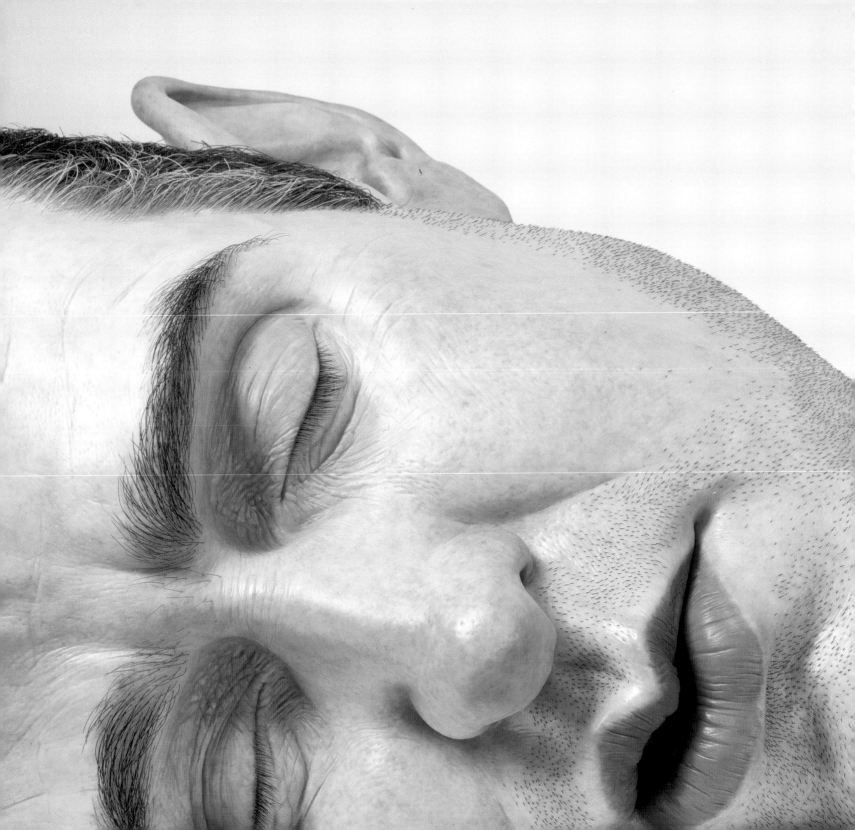

KEITH HARTLEY

Ron Mueck

NATIONAL GALLERIES OF SCOTLAND

EDINBURGH 2006

The National Galleries of Scotland is delighted that the first contemporary artist to be given a solo exhibition in the refurbished galleries of the Royal Scottish Academy Building is Ron Mueck. The stature of this Australian-born, London-based sculptor has continued to grow over the last few years and was confirmed by the recent, enormously successful show at the Fondation Cartier in Paris, which was visited by over 110,000 people. The five new sculptures that were shown for the first time in Paris are now being presented in Edinburgh, together with the very large new sculpture of a baby, *A Girl,* 2006 and four earlier works. This impressive group of sculptures provides a rare opportunity for the Scottish public and for British and foreign visitors to see and experience the physical and emotional power, as well as the astonishing range, of Mueck's work. It is a fitting show for us to mount during the Edinburgh Festival.

It is a pleasure to thank the artist for his commitment and enthusiasm over the past year, and for allowing us to interrupt his precious time with studio visits to observe work in progress.

Once again, Anthony and Anne d'Offay, Marie-Louise Laband and staff past and present at No.9 Dering Street – especially Laura Ricketts, James Elliott and Charlotte Burns – have done everything possible to make this exhibition happen. We would also like to thank Charlie Clarke for his vital technical input and Susanna Greeves for overseeing the project in its final stages. In London, Erica Bolton has been responsible for securing outstanding publicity for the exhibition, along with the Press and Marketing Departments of the National Galleries of Scotland. We are grateful to our Publications Department for getting this catalogue to press at comparatively short notice, and to Keith Hartley, deputy director of the Scottish National Gallery of Modern Art, for his thoughtful text.

Finally, we are deeply indebted to the lenders to the exhibition – Anthony d'Offay, Keith and Kathy Sachs, and Tate – as well as to our generous sponsor, Dunard Fund, and media sponsor, *The List* magazine. Without their support the exhibition could not have taken place.

John Leighton
Director-General, National Galleries of Scotland

Richard Calvocoressi
Director, Scottish National Gallery of Modern Art

Ron Mueck

KEITH HARTLEY

Ron Mueck has become renowned in the art world for his extraordinarily lifelike figures. He has emerged as a major sculptor, whose aim is to elicit an empathetic, emotional response from us, and he uses all the properties of figurative sculpture to do so: pose, gesture, facial expression, scale and realism.

Such is the power and verisimilitude of Mueck's realism that we find it hard to believe that his sculptures are modelled and not cast from life. But in this respect Mueck works in a traditional way. He makes small maquettes out of clay in order to establish the pose and configuration of a work. When he is satisfied with this, he makes a full-sized, detailed clay model, which he uses to make a mould from which he casts the figure in fibreglass (see page 45).

Although their astonishing veracity is perhaps the characteristic of Mueck's sculptures that has captured the public's imagination, realism in general, and sculptural realism in particular, is a more complicated issue than most people imagine. Art, almost by definition, requires a process of editing. As well as taking care to be as anatomically correct as possible, to colour the skin convincingly, to pay attention to as many of the creases and pores as we are likely to notice and to make the hairs on the head and body lie at exactly the right angle, Mueck does something that most realist artists have done before him: he exaggerates, ever so slightly, those features that denote life. It is our facial expressions that show we are alive and alert to our surroundings.

It is not, however, the verisimilitude in Mueck's sculpture

that ultimately matters but the ends to which this is put. The artist wants us to believe that his figures are experiencing certain emotions and experiences. Our suspension of disbelief is vital to his overarching concern, which is to capture the feeling of key moments in our passage through life. Although we may not recognise their significance at the time, these moments nevertheless represent the important stages of our changing self-consciousness and relationship with the world. In his work, Mueck has dealt with the themes of birth, infancy, youth, adolescence, sexual maturity, middle-age, old age and death. These are among the oldest subjects in the history of art and in literature; they recur, not just because of tradition, but because they matter. Many artists deal with one or two of these themes – love/sex and death are perennial favourites – but today few artists deal with the full cycle of life as Mueck does.

Closely connected with his exploration of the ages of man is Mueck's interest in human types, temperaments and emotional states. Again, he combines the individual with traditional themes. The woman in *In Bed*, 2005/6 [**7**] is a classic image of melancholia. Her chin rests on her hand as, sunk in thought, she stares into the middle distance. This is a recurring pose in Western art. Mueck has used variations of it in a number of works, notably *Big Man*, 2000 (Hirshhorn Museum and Sculpture Garden, Washington DC). It is a pose that suggests introspection, anxiety perhaps, but above all, one that shows the mind as being detached (as much as it even can be) from the body.

While *In Bed* and *Big Man* depict figures in a classic melancholic pose, other sculptures by Mueck also show figures deep in thought. In part, this is an inevitable result of creating a plausible pose for a figure, which has to be at rest and not caught in mid-movement or mid-gesture. Introspection is one of the few states of mind that lends itself to a static pose. One only has to think of Rodin's *Thinker*, c.1891 to realise how complete stillness is closely associated with mental concentration. *Seated Woman*, 1999 (artist's proof, The Broad Art Foundation, Santa Monica) presents a similar image of an introspective figure; however, Mueck does not depict an heroic, muscular young man wrestling with his thoughts, but an old woman pondering her own approaching death. At the other end of life Mueck created *Ghost*, 1998 [**1**]; a girl just on the threshold of puberty, whose self-absorbed expression seems to encapsulate her obsession with the changes happening to her body. She stares into the middle distance, too embarrassed to catch anyone's eye, so awkward does she feel at the enormous growth spurt that her body is experiencing. Mueck emphasises this by dressing her in a swimming costume so that her budding breasts are just noticeable, and having her lean against the wall so that her legs appear enormously long.

Creating the illusion of self-awareness is an essential aspect of many of Mueck's figures. It is even, and perhaps most poignantly, true of his babies. Watching a baby become aware of the separateness of its body from the world and the people about it is a

joy mixed with melancholy – joy that a new individual has entered the world, but melancholy that the process of individuation destines it to be alone, in the sense of being a separate consciousness, for the rest of its life. The tiny *Baby*, 2000 [2] has not yet developed the chubby cheeks of an older infant but still has the slightly wizened face of a newborn child. His enormous eyes seem to be focused on us, the spectator, or at least to show an awareness of our presence. The fact that the baby, totally unnaturally, is hanging naked on a wall serves to highlight his separation from his surroundings. It is almost as if he were being crucified, feet together, arms partially stretched out. Just as in old master paintings the pose and attributes of the Christ Child often prefigure his future Crucifixion, so Mueck makes us aware, if only subliminally, of the inevitable future trials and tribulations that the baby will have to endure.

As Mueck charts humanity's progress through life, one work stands out for its symbolic treatment of this journey. In *Man in a Boat*, 2002 [3] the artist places a naked, middle-aged man in a small, black boat. With no oars or sails he seems to be cast adrift on the sea of life. However, this does not instil in him fear or anxiety but rather curiosity, even an eagerness, to know what lies ahead. The man tips his head to the right and strains his eyes to try and divine what is in store for him. This is one of the few works by Mueck that utilises a prop, giving it somewhat the effect of a tableau. It is reminiscent of Puvis de Chavannes's symbolist masterpiece, *The Poor Fisherman*, 1881 (Musée d'Orsay, Paris), a painting that was inspirational for a whole generation of artists, including Picasso, in the late nineteenth and early twentieth centuries. Both Puvis's and Mueck's works deal with the theme of the mystery of life, but whereas Puvis uses a generalised, post-classical language, Mueck is quite specific – the man in the boat is a recognisable individual and the boat is real (a found object, in fact). Puvis's painting, true to the tenets of late-nineteenth-century French Symbolism, seeks to emphasise mystery and indeterminacy. It wants us to linger in a twilit world where there are no answers but an ever-expanding range of possibilities. Mueck's work, on the other hand, uses the language of realism to pose the same question. Because realism lends itself to empathy, we can identify with the man in the boat; the mystery is, therefore, not specific to the work itself but to our own future.

The recent work *In Bed* also has a tableau-like quality to it. Here Mueck uses a combination of scale (the woman and bed are almost twice life-size) and a familiar, comforting setting to activate feelings in the viewer of childhood – of seeking out protection in the maternal bed. However, instead of finding a warm welcome, we find a woman lost in thought, her eyes not focused on us but staring vacantly ahead. What Mueck manages to do is to harness the intensity of childhood memories to the way that we attempt to engage emotionally with the figure of the woman. We empathise with her seeming anxiety, but can find no way to get past her fixed stare.

Except for a sculpture of a mother with her newborn baby – *Mother and Child*, 2001 (Robert Lehrman Art Trust, Washington DC) – until recently Mueck had made no sculptures that included more than one figure. He then made two, *Two Women*, 2005/6 [9] and *Spooning Couple*, 2005 [6]. The sculpture *Two Women* consists of two elderly women engaging in gossip. They are much smaller than life-size and stand on a plinth. Their size encourages us to examine them close-up, to look at the wrinkles on their faces and the creases in their stockings. We then begin to see that their sideways glances and conspiratorial expressions are not entirely benign. These are not sweet, little old ladies but potential mischief-makers. The fact that the sculpture is of two figures rather than one encourages us to read a narrative into the work.

This is even more the case with *Spooning Couple*. The figures are lying together on a low plinth so that we look down on them from a bird's eye, or perhaps godlike, perspective. The man, naked from the waist down, and the woman, naked from the waist up, are lying together, almost in a foetal position, her body fitting into the hollow of his like spoons. They may be 'spooning' in a literal way, but in the rather quaint, metaphorical sense of making love (especially in a sentimental or silly fashion) they are in anything but a warm, loving embrace. Their expressions show them to be deep in their own separate worlds. The man almost catches the viewer's gaze in complicit acknowledgement that the bond between him and the woman seems to have broken

down. At an earlier stage in the making of this work, Mueck had had the man's arm holding the woman; by moving it away, he altered the whole relationship between the couple. This shows how fluid Mueck's creative process is and the vital importance that he attaches to the physical making of his works. New solutions and new psychological insights can occur at any stage.

Another example of this openness and lack of preconception is *Wild Man*, 2005 [5]. This portrays a hairy, naked man with a thick beard and long straggly hair sitting on a stool. His face shows signs of extreme anxiety, even terror; he grips the stool and his toes press down onto the floor. He is clearly frightened of something and his nakedness makes him look doubly vulnerable. All this contrasts with what would normally be the reaction of visitors who walk around him. Measuring nearly three metres, seated, he is a giant. As his name suggests and his looks imply, he derives from the wild man of the woods of the late medieval, north-European imagination – the still uncivilised, unchristianised counterpart to the chivalrous ideal of that time. The wild man's aggression – in most traditional images he carries a club – is a reminder of man's untamed inner nature, always threatening to break out and destroy the thin veneer of civilisation.

However, although Mueck's *Wild Man* looks the part, his state of cringing fear elicits a sympathetic response from the viewer. Instead of our feeling intimidated by him, he seems intimidated by us. Mueck's initial idea for this sculpture was to make a figure who felt backed into a corner and was literally cowed. However, it

was only after he had seen an illustration of Giambologna's sculpture of a hirsute river god, *Appennino* (Parco Demidoff, Pratolino), that he decided to make him a seated figure and turn him into a frightened wild man.

There is one category of sculpture in Mueck's work where verisimilitude is limited to a frontal view. Up to the present Mueck has made three masks. The first two, *Mask*, 1997 (Private Collection) and *Mask II*, 2001–2 [4] are loosely based on his own physiognomy, and the most recent, *Mask III*, 2005 [8] on that of a black woman. By their very nature masks are a façade with no substance behind them. They are used to conceal, to hide behind: sometimes to frighten and sometimes to entertain.

Mask II is presented as a plainly artificial object. It lies on its side on a plinth. The side of the face that is next to the plinth looks as though it is part buried by a pillow. The eyes are closed, strengthening the impression that the work represents the head of someone asleep. There is a long tradition in the history of sculpture of artists making works based on the human head. It is the most expressive part of the human body and the part upon which we tend to concentrate our gaze. Most of the famous sculptural heads of the modern movement have tended to be either expressive, highly abstracted or sometimes classical, but few have been as realistic as Mueck's *Mask II*.

Mask III, by contrast, is highly idealised, made to have even rounder and more benign-looking features than the person it was based on. Shortly before he made the work Mueck had visited an exhibition containing a number of sculptures of the Buddha. In *Mask III* he attempted to capture some of the inner peace and sense of beatitude of these Buddhas. The head is as round and calming as a full moon.

If masks seem to stand out in Mueck's work as a marriage of realism and the fragment, this fact merely serves to throw light on what Mueck is attempting to do in all his sculptures. Ultimately it is not their lifelike qualities but their expressive power that counts. Realism is just one of the factors forcing the viewer into an intense confrontation with the figure. In the end Mueck uses every device at his disposal to make us enter the emotional world of his cast of characters.

The recently completed monumental sculpture of a newborn baby, *A Girl*, 2006 [10], shown for the first time in Edinburgh, is the latest to engage our rapt attention. Hands and arms held down beside her body, her head stretched out towards us, the baby seems to be testing out the space she occupies in the world. In fact, the pose is quite unnatural for an infant – normally a baby would hold its hands up towards it face – but Mueck wants to suggest the assertiveness of a new life force. More important to him than a slavish adherence to reality is the ability to capture the underlying truths of life and, of equal significance, to make us believe them.

1 Ghost 1998
mixed media · 202 × 65 × 99cm
Illustrated overleaf, detail opposite

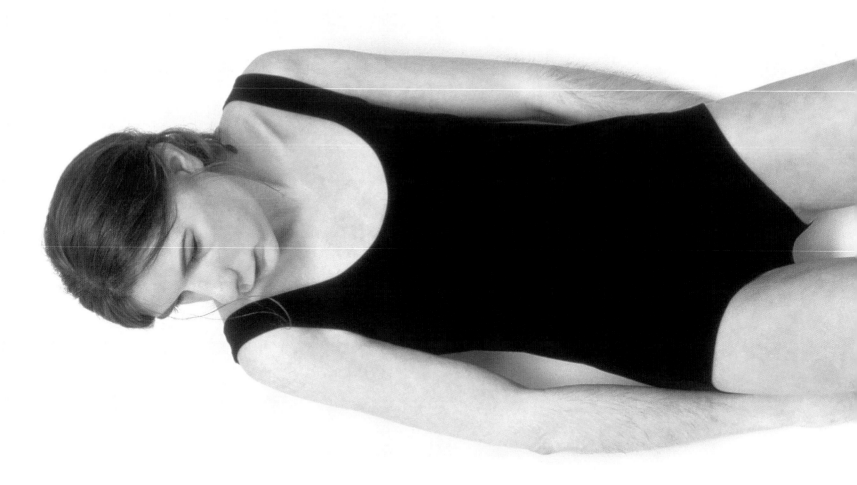

2 Baby 2000
mixed media · 26 × 12.1 × 5.3cm

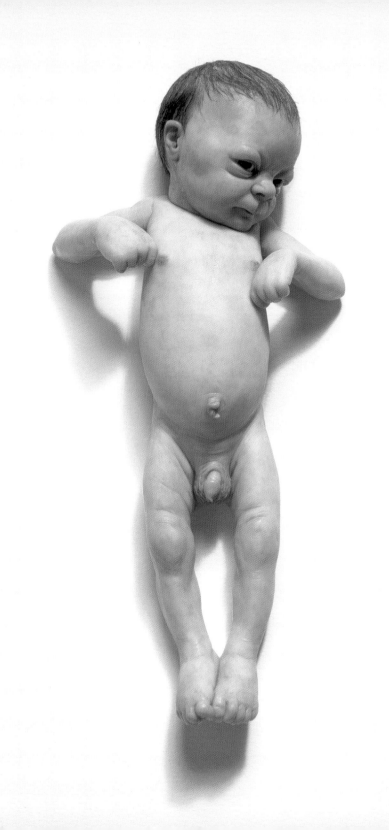

3 Man in a Boat 2002

mixed media · figure 75cm high; boat 421.6 × 139.7 × 122cm

illustrated overleaf, detail opposite

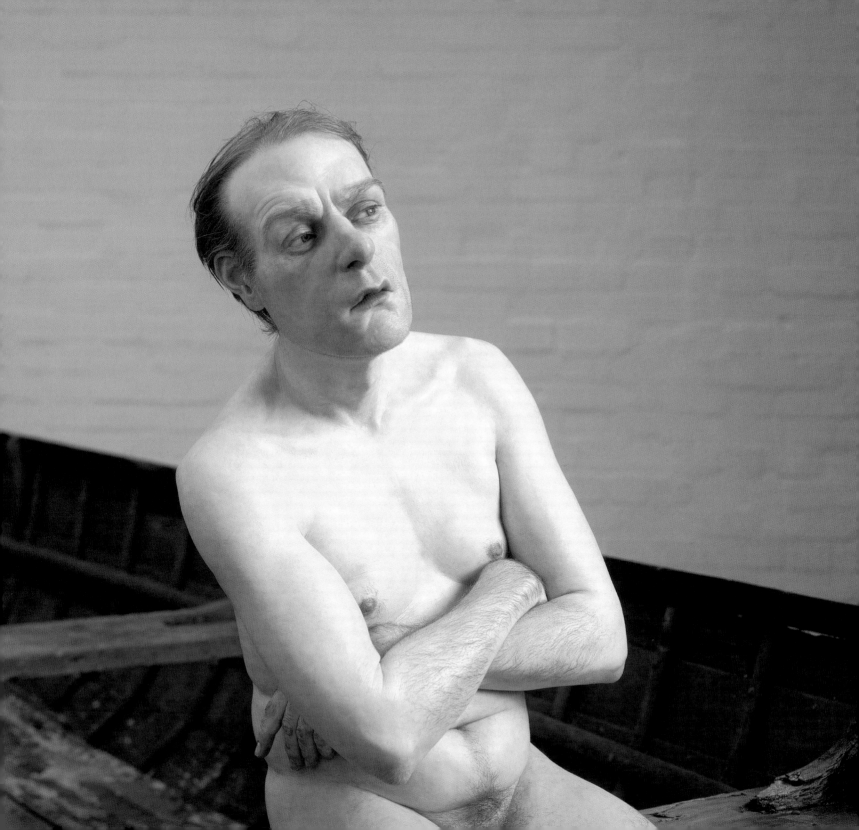

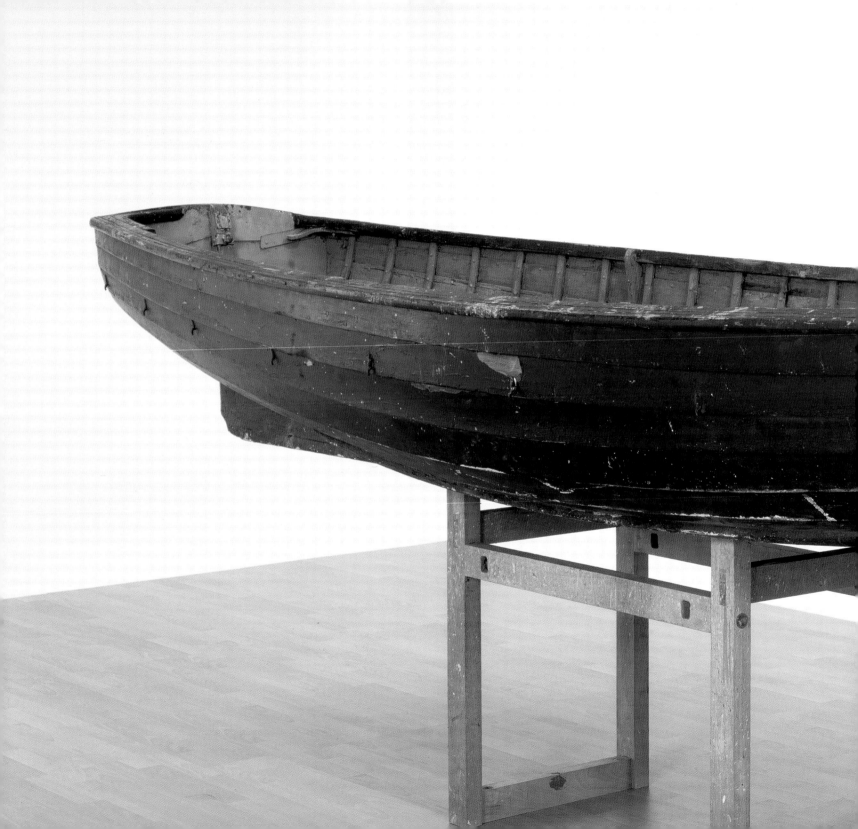

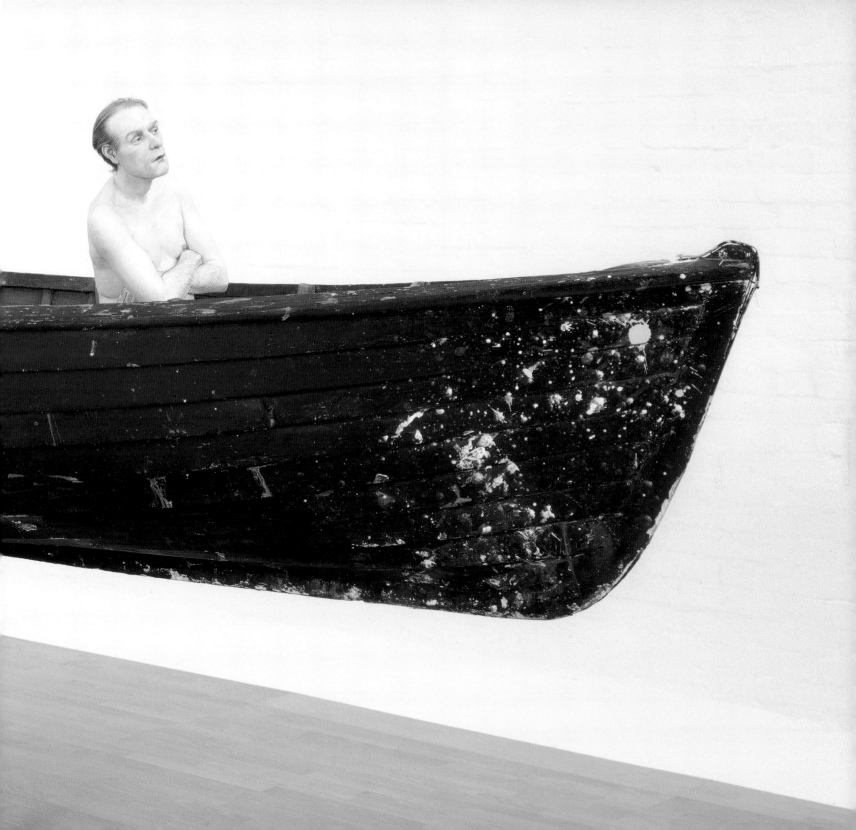

4 Mask II 2001–2

mixed media · 77 x 118 x 85cm

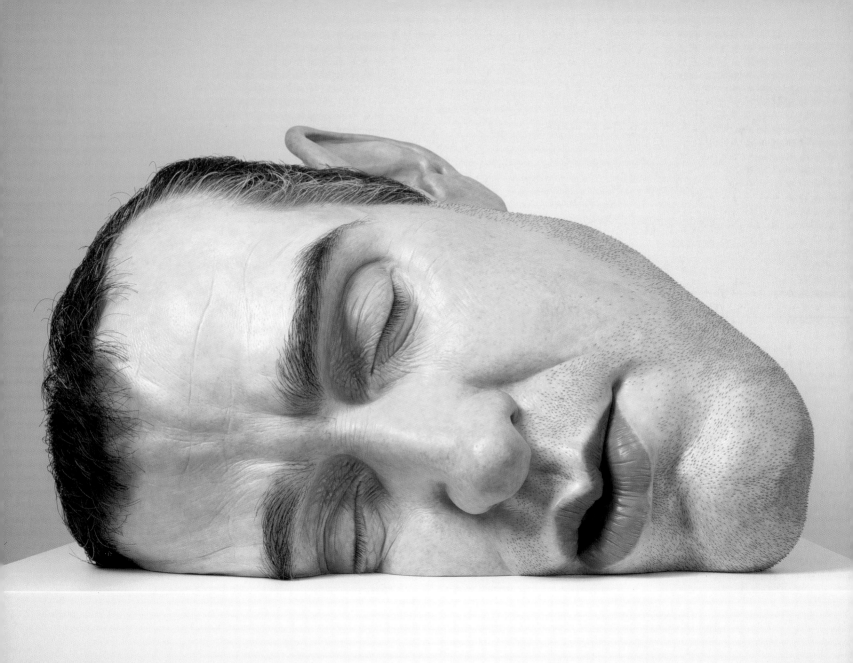

5 Wild Man 2005
mixed media · 285 × 162 × 108cm
illustrated overleaf, detail opposite

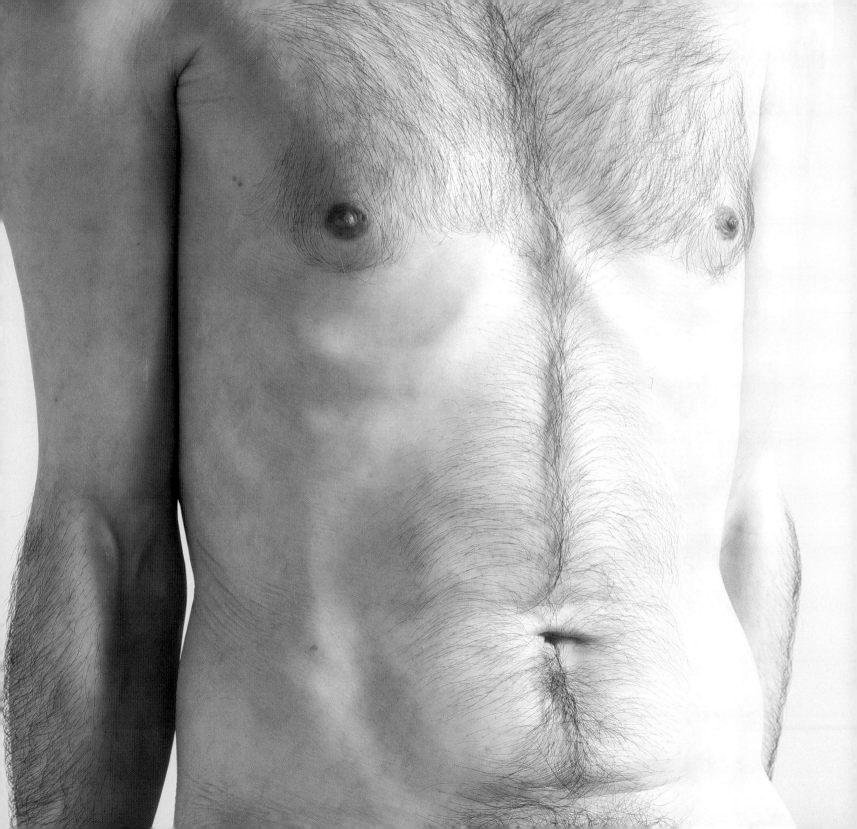

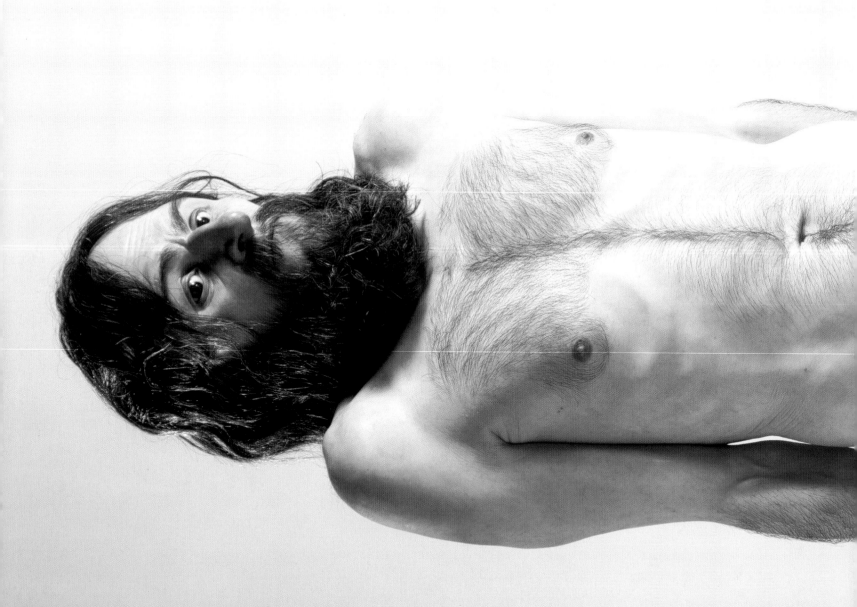

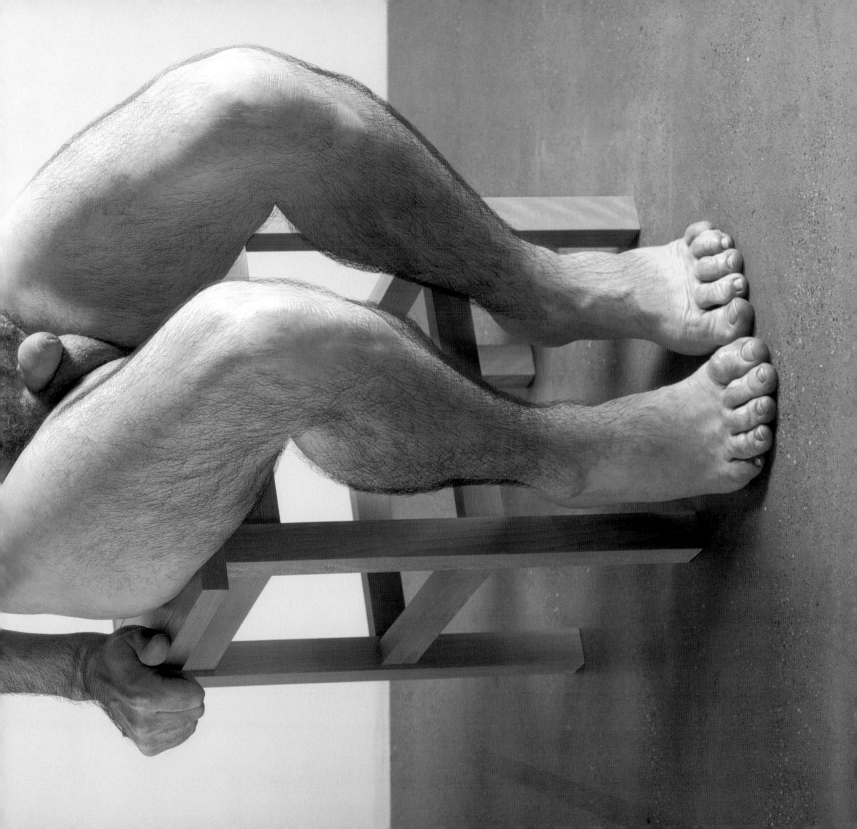

6 Spooning Couple 2005
mixed media · 14 × 65 × 35cm

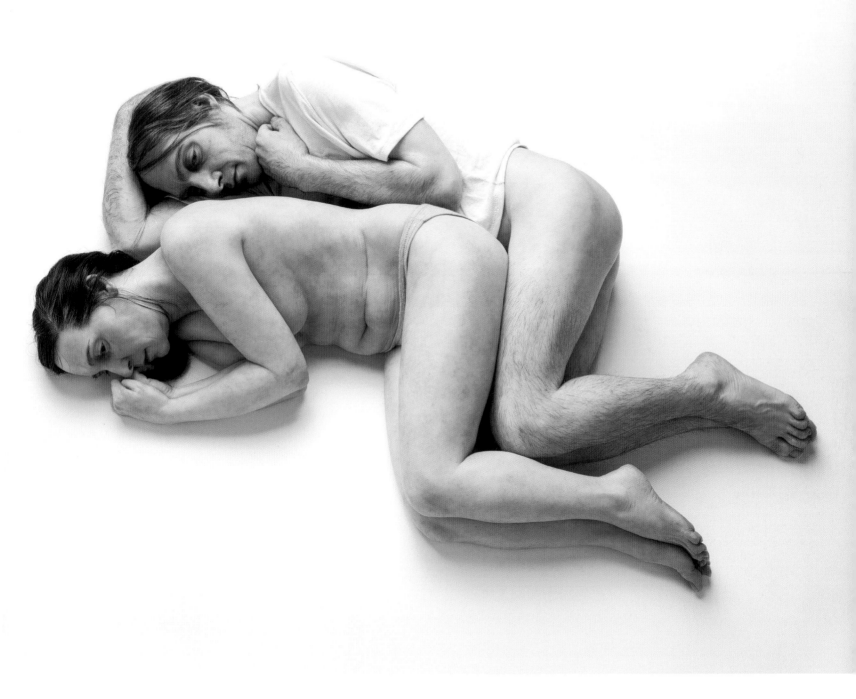

7 In Bed 2005
artist's proof installed at Fondation Cartier, Paris
illustrated overleaf, detail opposite

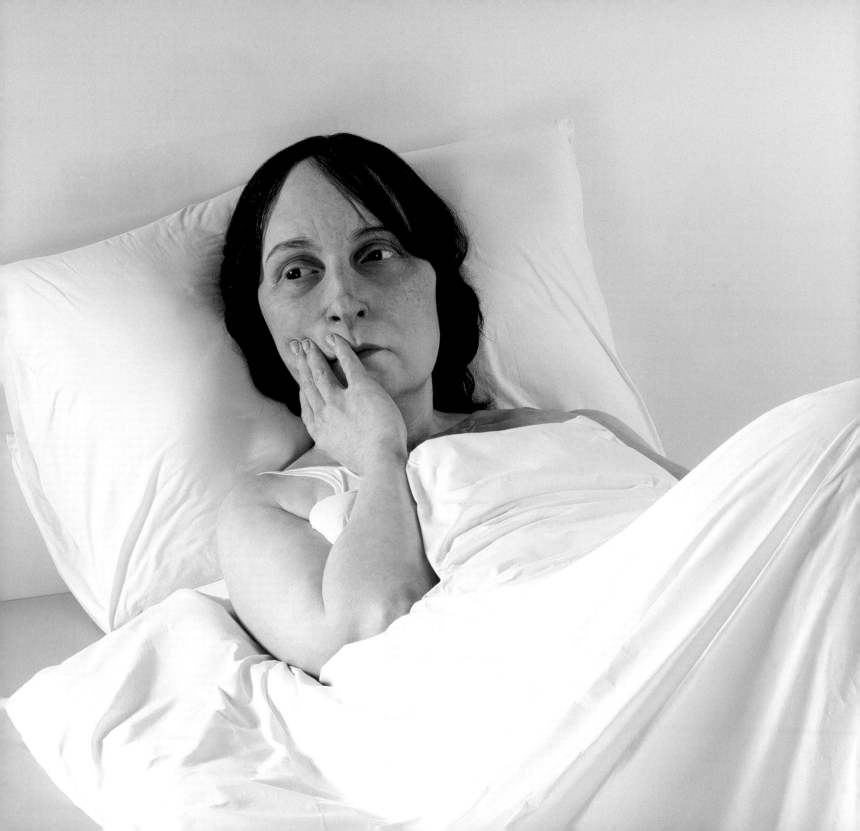

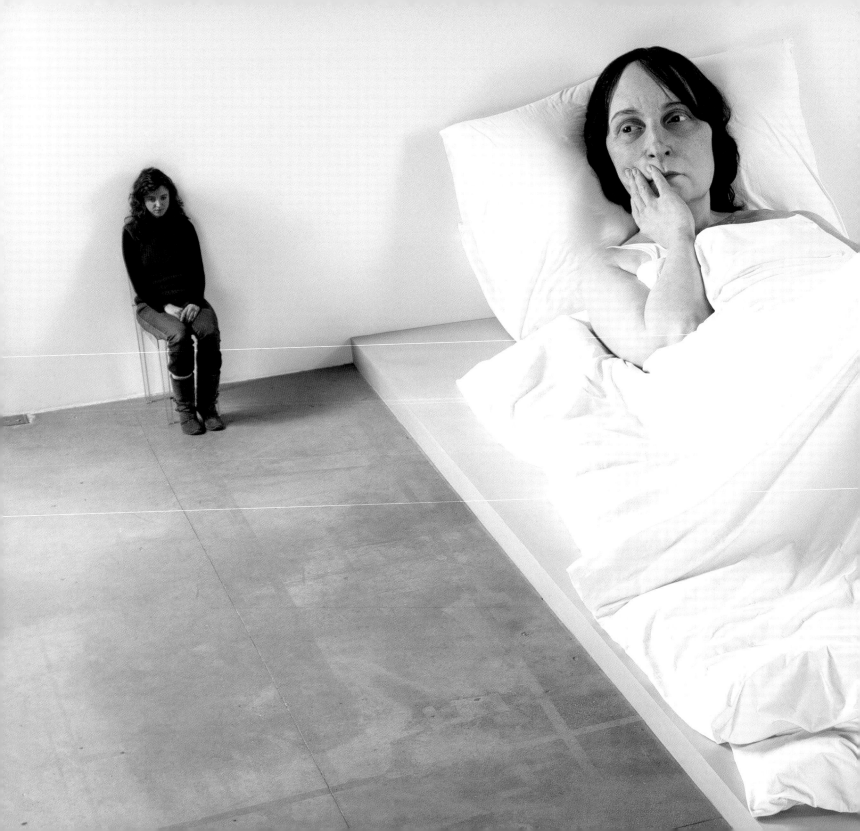

8 Mask III 2005
mixed media · 155 x 132 x 113cm

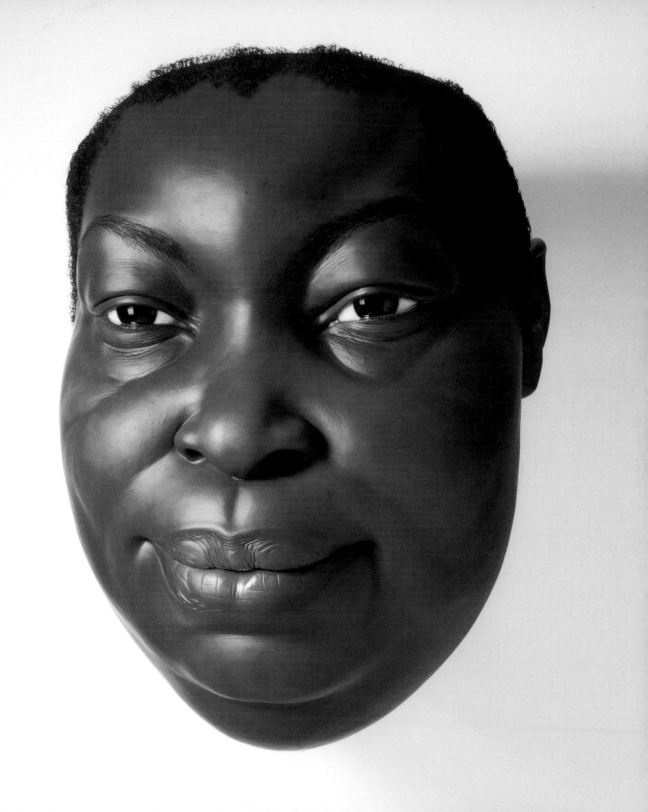

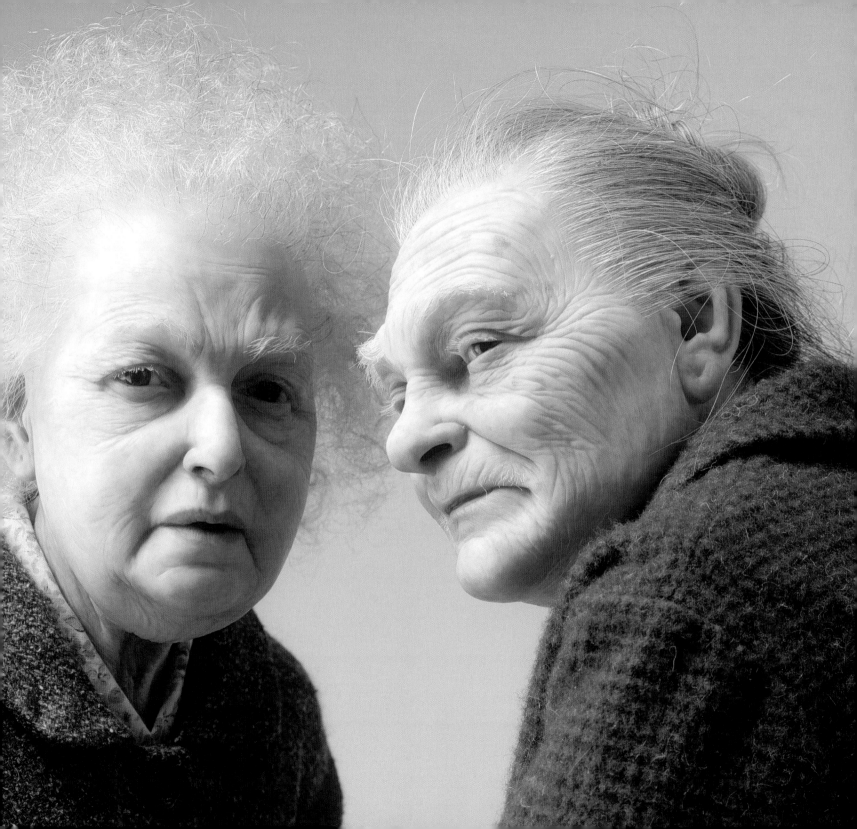

9 Two Women 2005
artist's proof installed at Fondation Cartier, Paris
illustrated opposite, detail on previous spread

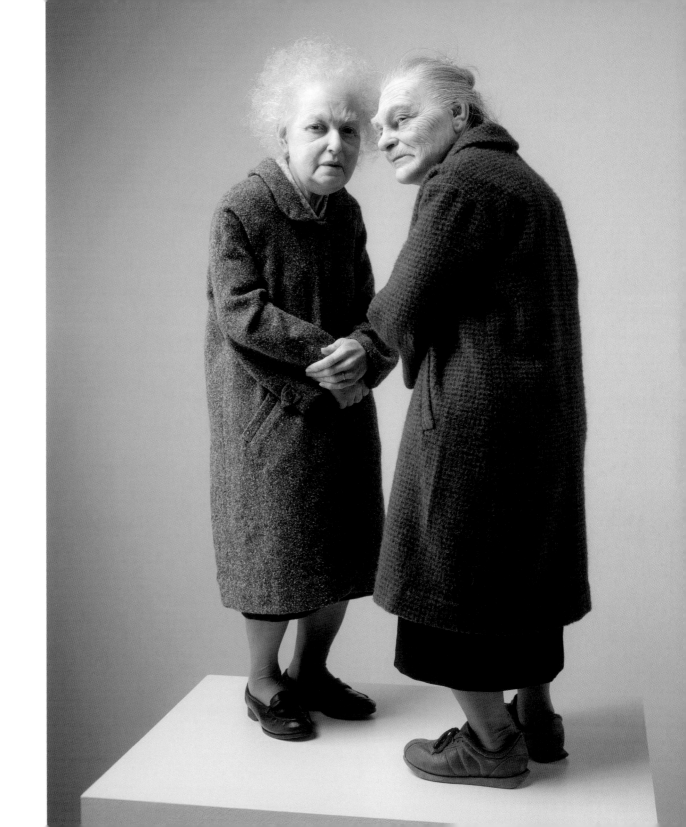

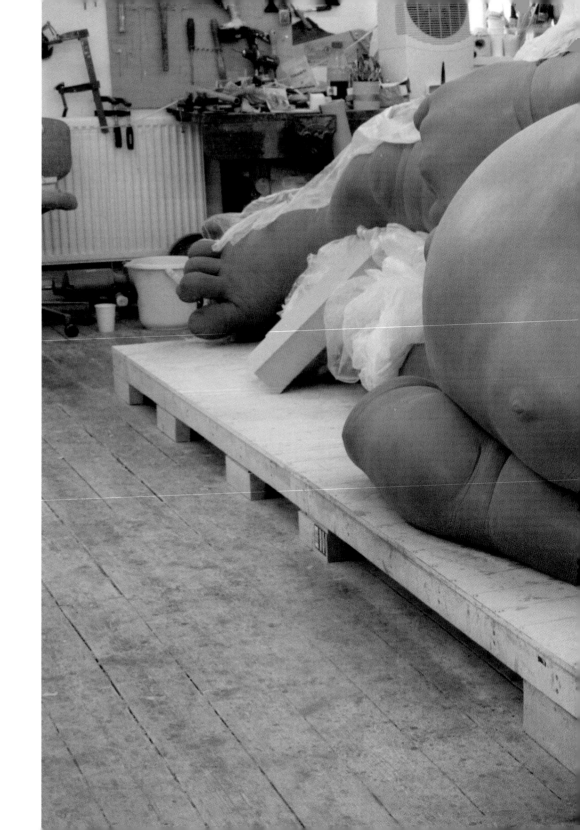

10 A Girl 2006

mixed media · 110.5 × 134.5 × 501cm

illustrated in unfinished state

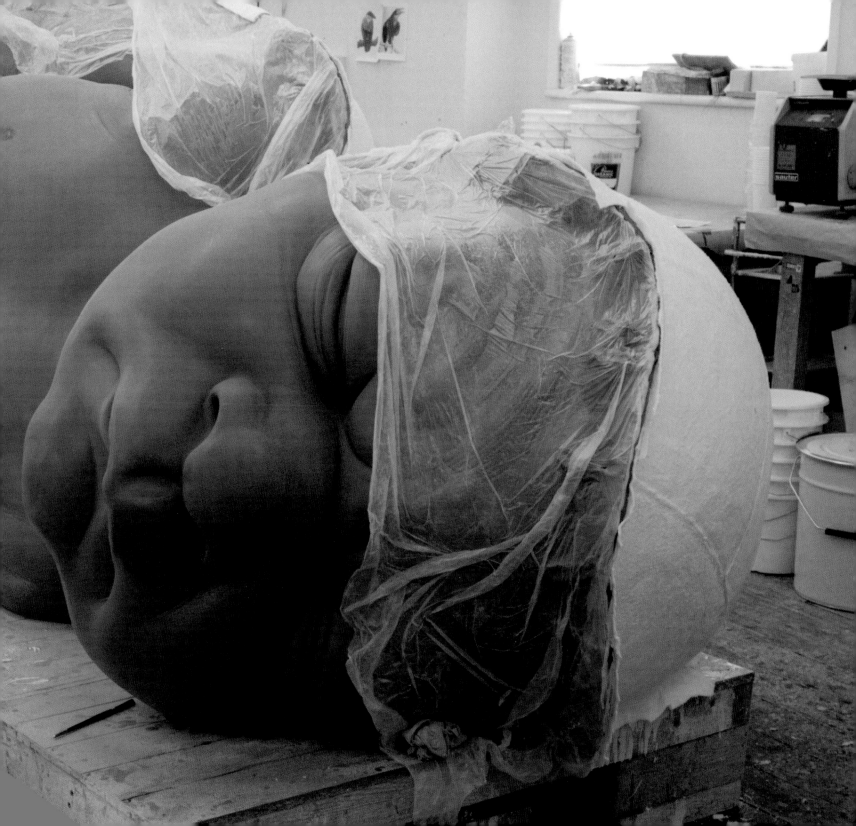

Ghost 1998
mixed media · 202 × 65 × 99cm
edition 1/1
Tate. Purchased 1998

Baby 2000
mixed media · 26 × 12.1 × 5.3cm
artist's proof
Keith and Kathy Sachs

Man in a Boat 2002
mixed media · figure 75cm high · boat 421.6 × 139.7 × 122cm
edition 1/1
Private Collection

Mask II 2001–2
mixed media · 77 × 118 × 85cm
artist's proof
Private Collection

Wild Man 2005
mixed media · 285 × 162 × 108cm
artist's proof
The Artist

Spooning Couple 2005
mixed media · 14 × 65 × 35cm
artist's proof
The Artist

In Bed 2006
mixed media · 162 × 650 × 395cm
edition 1/1
Anthony d'Offay, London

Mask III 2005
mixed media · 155 × 132 × 113cm
artist's proof
Anthony d'Offay, London

Two Women 2006
mixed media · 85 × 48 × 38cm
edition 1/1
The Artist

A Girl 2006
mixed media · 110.5 × 134.5 × 501cm
artist's proof
Anthony d'Offay, London

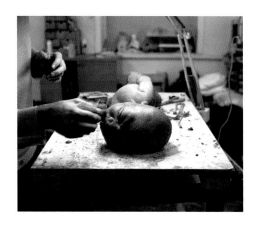

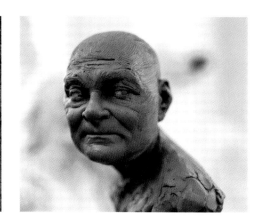
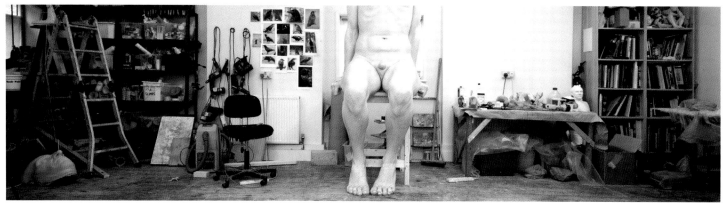
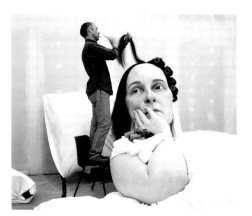
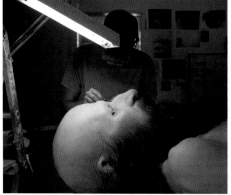
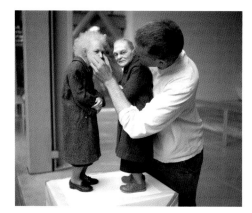

Ron Mueck's sculptures are obviously not cast from life, since none of his figures are life-size. They spring from the germ of an idea, which is nurtured and often influenced by photographs of people and works of art he has seen. Mueck uses drawings and small clay maquettes to refine his ideas, until he is happy with the results. He then proceeds to sculpt the figure in clay. In the case of large-scale sculptures he first makes a series of plywood cross-sections (worked out mathematically on a computer), which he covers with chicken wire, cheesecloth and plaster. Once dry he applies modelling clay.

When modelling is finished, Mueck makes a mould, or rather a series of mould-sections, around the clay figure. To do this he applies a layer of silicone to the figure, which captures all the fine surface detail. On top of this, various layers of resin and finally fibreglass are added to give the mould stability. He then removes the mould from the model.

Mueck is now in a position to make the sculpture itself. He tints polyester resin the particular colour he wants for each part of the body and paints this onto the inside of the respective part of each mould. When the resin has hardened, he is able to release the (positive) parts of the body from their (negative) moulds and can now fit them all together. The seams are sanded down, glued together and painted so that they do not show. This is also the stage at which Mueck is able to make any last-minute adjustments to the skin colour before the body hair is added.

In the case of small-scale figures, human hair is used; with the larger than life-size figures coarser horse hair or acrylic fibre is used. Each strand of hair has to be inserted into the polyester resin individually. Clothes are made specially for the figures, if nothing of the right size is available off the peg. The final parts to be fitted are the eyes.

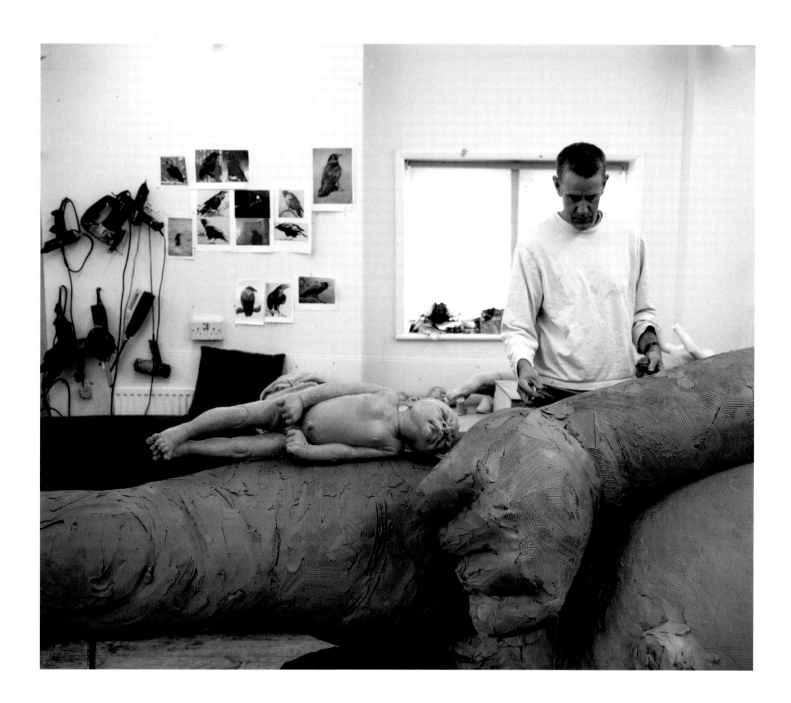

1958

Ron Mueck born in Melbourne, Australia. Both parents were originally from Germany.

1979–83

Worked in children's television.

1986

Spent six months in Los Angeles. Moved to London, where he worked in Jim Henson's Creature Shop.

1990–6

Founded his own production company in London to make props and models, designed to be photographed from one angle, for the advertising industry. During this period he began to use fibreglass resin to make highly realistic models.

1996

Began to work as an independent sculptor. The first public exhibition of his work came when the artist Paula Rego included his sculpture *Pinocchio*, 1996 among her paintings in the exhibition *Spellbound: Art and Film* at the Hayward Gallery, London.

1997

His sculpture *Dead Dad*, 1996–7 was included in the exhibition *Sensation: Young British Artists from the Saatchi Collection* at the Royal Academy, London and made his name. The show travelled to Berlin and Brooklyn.

1998

First solo exhibition at Anthony d'Offay Gallery, London.

2000

Made Associate Artist at the National Gallery in London, a two-year post. Made *Mother and Child,* 2001, *Man in a Boat*, 2002, and *Crouching Boy in Mirror*, 1999–2002 while he was there. The huge sculpture *Boy*, 1999 was shown in *The Mind Zone* at the Millennium Dome in London. The same work was shown in the Corderie at the 49th Venice Biennale in 2001.

2002

Exhibitions: *Directions: Ron Mueck* at the Hirshhorn Museum and Sculpture Garden, Smithsonian Institution, Washington DC; *Ron Mueck: Sculpture* at the Museum of Contemporary Art, Sydney.

2003

Exhibitions: *Ron Mueck: Making Sculpture at the National Gallery*, National Gallery, London; *Ron Mueck* at the Nationalgalerie im Hamburger Bahnhof, Museum für Gegenwart, Berlin.

2005–6

Exhibition at the Fondation Cartier, Paris.
Lives and works in London.

Published by the Trustees of the National Galleries
of Scotland 2006 for the exhibition *Ron Mueck* held at
the Royal Scottish Academy Building, Edinburgh from
5 August to 1 October 2006

Works © Ron Mueck
Text © The Trustees of the National Galleries of Scotland
Studio photography © Gautier Deblonde
[1] © Tate, London 2006; all other photography
© Anthony d'Offay, London

ISBN 1 903278 83 X / 978 1 903278 83 3

Designed and typeset in Shaker by Dalrymple
Printed in Belgium by Die Keure

Front cover: Ron Mueck working on *Mask III*
Frontispiece: *Mask II*, 2001–2 (detail)
Back cover: Ron Mueck and *Mask III*